# Fat and Skin Folds

## Michel Lauricella

MORPHO

anatomy for artists

**rocky**nook

Morpho: Fat and Skin Folds: Anatomy for Artists
Michel Lauricella

Editor: Joan Dixon
Project manager: Lisa Brazieal
Marketing coordinator: Mercedes Murray
Graphic design and layout: monsieurgerard.com
Layout production: Hespenheide Design

ISBN: 978-1-68198-504-6
1st Edition (4th printing, June 2023)

Original French title: Morpho: Graisse et plis de peau
© 2018 Groupe Eyrolles, Paris, France
Translation Copyright © 2019 Rocky Nook, Inc.
All illustrations are by the author.

Rocky Nook Inc.
1010 B Street, Suite 350
San Rafael, CA 94901
USA
www.rockynook.com

Distributed in the UK and Europe by Publishers Group UK
Distributed in the U.S. and all other territories by Publishers Group West

Library of Congress Control Number: 2018966895

This book is printed on acid-free paper.
Printed in China

# table of contents

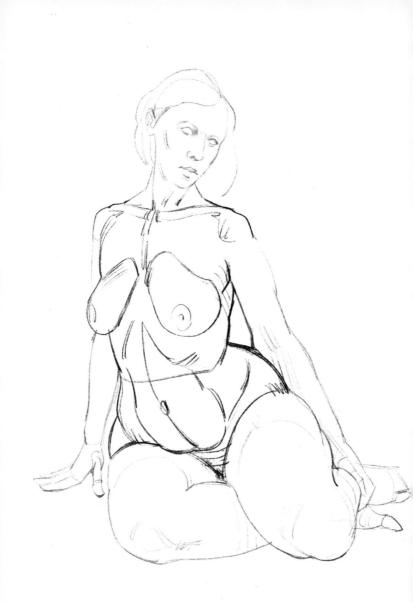

# foreword

The various shapes of the human body can be broadly divided into three structures, each of which is of equal importance for drawing: the skeletal structure, the muscular structure, and the fatty structure.

In this book, we focus on the shapes that result from the subcutaneous fat that covers the écorché of the body (made up of the bones and muscles). We will build upon the skeleton's bony reference points and will return to these principal elements as needed. The fat by no means entirely masks the skeleton: On the contrary, it lets the skeleton show through in many places, particularly at the joints.

There are certain points on the body where the skin adheres directly to the bones. It is at these points that the fat creates furrows, dimples, and anchoring points on the skin, which betray the skeleton's presence.

The body's fatty regions have their own specific names. Professor and author Dr. Paul Richer (1849–1933) called the fatty volume at the back of the arm the "postdeltoid fat region" and the one underneath the hip joint the "subtrochanteric fat region." He also referred to the "cervicodorsal" and "prepubic" fat regions. The existence of this lexicon implies the ubiquitous presence of these fatty spots. These fatty shapes can feminize or masculinize the human silhouette, accentuating the sexual characteristics of your figures or, conversely, they can minimize the differences and make your figures appear more androgynous.

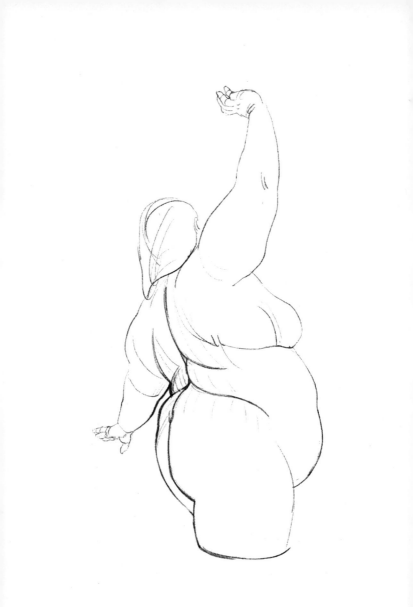

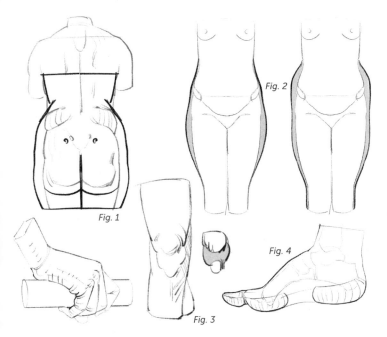

Fig. 1

Fig. 2

Fig. 3

Fig. 4

# introduction

Fat, which lines the skin, varies in thickness not only from one person to another, but also from one area to another on each individual person (Figs. 1 and 2). There is a kind of fat called interstitial fat that is located under the general fascial envelope, a fibrous tissue that completely covers the skeletal and muscular structure. The quantity of this fat does not vary by much. It slips between the vessels, nerves, ligaments, and muscular insertions. In some places it can influence external shapes: It fills out the hollows under the cheekbones, in the armpits, at the top of the legs, and behind the knee, and it slips between the quadriceps tendon under the kneecap and the shinbone to form part of the joint (Fig. 3).

The fat that covers the tips of the fingers and toes is also quite consistent in quantity and provides padding, protection, and shock absorption. It allows our hands to get a better grip by molding itself around the objects that it grasps. It can be up to 3/4 of an inch thick on the sole of the foot, playing the role of a natural shoe (Fig. 4).

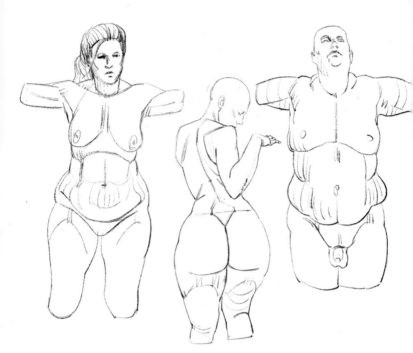

The fat that we will be discussing in this book is mostly superficial. It is subcutaneous and lines the skin. Its thickness can be easily estimated by pinching your skin: What you have between your fingers is a double thickness of skin as well as a double thickness of fat. In many areas of the body it varies according to how overweight a person is. Some fatty forms do not appear until puberty. More often present on female models, some fatty forms are considered as secondary sexual characteristics. They can be very pronounced in specific parts of the body on people who are not fat otherwise. There are many individual variations. The body can be globally wrapped in fat to a lesser or greater degree, and the localized deposits and layers can develop in completely different proportions. At their edges, they can fade or become

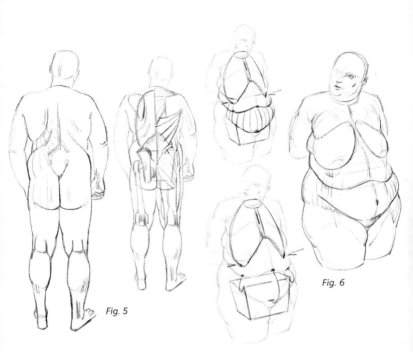

Fig. 5

Fig. 6

more pronounced. Therefore, we must be prepared for an infinite variety of relative thicknesses of each of these various forms, with no particular necessary correlation between them. These fatty forms do not coincide with the muscular system (Fig. 5).

The skin is an elastic envelope, lined with a fatty layer that adheres tightly to its underside. The skin's elasticity lessens with age, which draws wrinkles in it. The folds in the skin correspond to the joints and are reinforced by flexing, extending, and rotating movements, much like the folds of an article of clothing. The places where the skin adheres to the skeleton (Fig. 6) cause more defined folds and dimples in those spots.

Finally, folds can also be caused by the direct action on the skin of the platysma muscles of the face and neck.

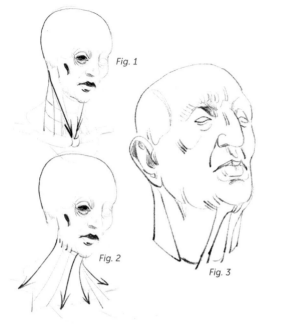

Fig. 1

Fig. 2

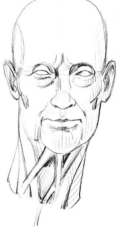

Fig. 3

## Head and neck

Fat can be easily detected in the cheek area. With increasing weight, it slips everywhere else under the skin. It simplifies forms and softens the bony shape of the skull. As a person ages, the relaxation of the skin produces the impression of soft tissues hanging from the skull, which causes outcroppings at its peaks: the forehead, the eye sockets, and the cheekbone arch. Wrinkles appear as a result of the repeated action of the platysma muscles, which are under the skin and are connected to the bone. Their basic mechanical function is to vary the natural openings of the face, around the eyes and the mouth, and to participate in language and the expression of emotions. Their contractions are what cause the face's folds and wrinkles, which are perpendicular

to the direction of the muscular fibers. Apart from the masseter and temporal muscles, which are powerful chewing muscles, then, it is not the face's muscles that we draw but rather their action on the skin: the folds and wrinkles.

On the neck, once again, fat can soften the shapes, and the repeated movements of flexing and extending can imprint their action on the skin as circular wrinkles. Note that with age the platysma muscle of the neck relaxes. Fig. 1 is a sketch of this region without this muscle: It is drawn in on Fig. 2, and shown as we usually see it on Fig. 3.

At the junction of the neck and the back, the seventh cervical vertebra can be capped by a small fatty deposit that softens its contour while giving it a higher outline.

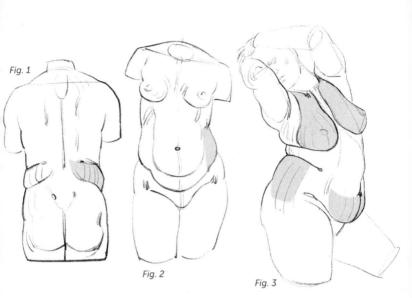

Fig. 1

Fig. 2

Fig. 3

## Torso

The buttock is the largest fatty region on the body. We will discuss it a little later along with the lower limb.

The flank is muscular in the front and fatty in the back. This fatty area begins in the space that is left free between the latissimus dorsi and oblique muscles on the muscular framework, as though to fill in this empty space. From there, the fat takes various shapes, but as it develops, it always rises up toward the back, creating a fleshy bulge.

This fatty location on the flank can connect, in front, with the abdomen's fatty volume (Figs. 1 and 2, more masculine shape). In this case, the fat forms a fleshy belt that continues around the abdomen, making the hips underneath appear narrower, especially if the pelvis is naturally narrower.

But the fat can also go beyond this bone boundary, passing above the iliac wings and connecting with the hips and the top of the buttocks (Fig. 3, more feminine shape). In this last case, the waist effect will be reinforced, especially if the pelvis is naturally wider. The drawings on page 12 show the two basic configurations I have seen on many models, both feminine and masculine. I have not been able to choose one over the other. Fat lessens and blurs sexual characteristics, often making shapes androgynous.

There are, of course, many variations and nuances, and some folds can double up. I have not accounted for all of that in this summary text.

In the abdomen, the fat is mainly located around the navel (Fig. 3), and the navel looks deeper when more fat

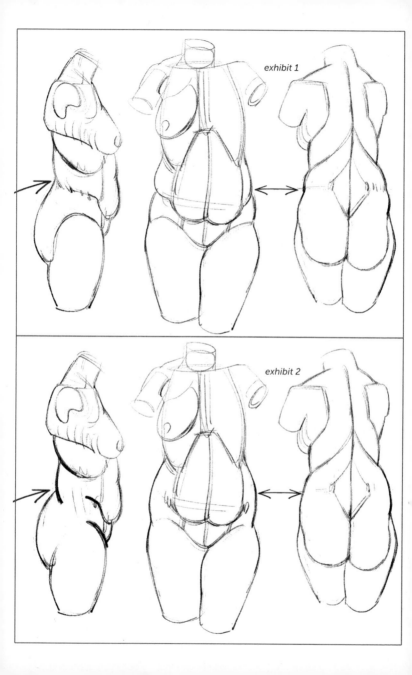

*exhibit 1*

*exhibit 2*

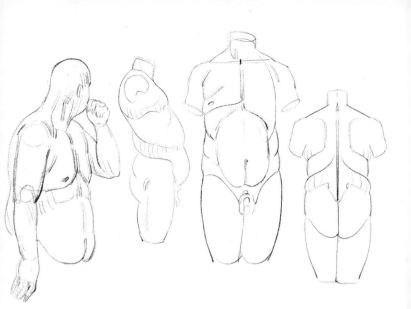

is there. The fat in this region can extend below the navel and through all the area between the waist and the pubis, and from there can extend around back to merge with the fatty bulge at the flank and, as we have seen, connect with the hips and the buttocks.

The shape of the breast, constituted by the fat that surrounds and appears to protect the mammary glands, varies greatly from one person to the next and is not necessarily in proportion with the fat found on other areas of the body. The fat here is kept in a pocket of skin connected to the clavicle, which carries it along with all movements of the arm (page 11, Fig. 3). One can see the breast sliding along the breastplate and the rib cage, with which it has no direct connection. On a masculine model, you will often find a fatty volume around the nipple, which can also develop into the shape of a breast. It is still the pectoral that is re-

sponsible for the volume to the front of the armpit wall, but it will sometimes be covered by the fat surrounding the nipple.

From here, as it increases, in either sex, the fat will connect in back with the scapula, and will create a bulge that makes a nice pattern, echoing under the arm the oblique volume of the flank described above.

The volume of the rib cage slides between these two fleshy bands at the level of the waist. Twisting or bending movements emphasize the presence of this fatty area.

The pubic fat covers the pubic symphysis at the pelvis. It is triangular on a female model, limited by the fold of the abdomen above and, on the sides, by the flexion folds of the thighs. On a male model, the fat, as it increases, will envelop the base of the penis and partly cover it, making it appear shorter.

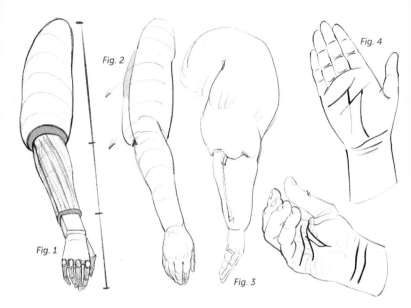

Fig. 1

Fig. 2

Fig. 3

Fig. 4

## Upper limb

The fat on the limbs decreases as it moves from the root to the extremities.

Fat can be more easily found close to the shoulder; below that, on the forearm, it is muscle that is more dominant. The skeletal frame is more prominent at the extremities: around the wrist, and on the back of the hand. Therefore, one has the impression of three layers (Fig. 1) that overlap in a series from top to bottom: The fat passes the baton to the musculature and the skeletal frame takes over at the back of the fingers. On a limb with chubby hands, then, the fat will be much thicker at the root of the arm.

At the back of the deltoid there can be a fatty form that is separate from the musculature there (Fig. 2). When it is present, it enlarges the profile of the arm. The fat reinforces certain bony ref-

erence points, such as the ulna (from the elbow to the wrist, Fig. 3) and the heads of the metacarpals (in the fist), which appear as small depressions or dimples.

On the palm of the hand, we can see the flexion fold of the thumb, which runs from the axis of the wrist towards the index finger, as well as the fingers' flexion fold, which follows the heads of the metatarsals and stops between the index and middle fingers. Two accessory folds follow them, further in. The thumb's accessory fold is on the axis of the middle finger, and the fingers' accessory fold stops between the ring finger and the little finger. Taken together, these four folds make the shape of the letter M (Fig. 4). Two or three flexion folds also appear at the wrist.

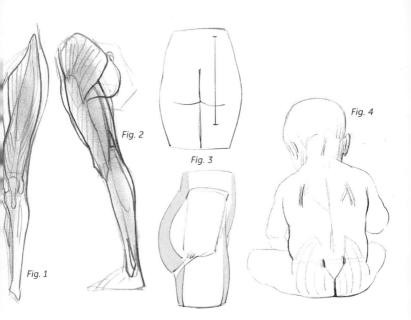

Fig. 1

Fig. 2

Fig. 3

Fig. 4

## Lower limb

On the legs, as with the upper limbs, the fatty layers diminish as they move from the root to the extremities (Fig. 1). The exception here is that the inside of the knee is sometimes covered in a layer of fat, and the bottom of the foot always has a fatty layer.

Fat is principally responsible for the shape of the buttocks. The muscle is draped with fat (Fig. 2), which is responsible for the gluteal fold and the line of the buttocks, whose length is a function of the quantity of fat. This gluteal fold is a result of the fibers that connect the skin to the ischium (the lower end of the pelvis). On certain models, this "fibro-cutaneous pocket" (Fig. 3), can pull away; relax, with age, at the buttocks' lower internal angle; and separate itself from the gluteus maximus muscle, which extends further down.

As we have already explained, the buttocks can blend into the volume of the hips and connect with the flank. In such cases, the buttocks may appear to reach up to the waist (Fig. 4).

A particularly feminine fatty shape can be found below the hip joint (Fig. 5). The curve that it draws on the contour of the thigh is not symmetrical. It is thickest just below the hip joint and quickly loses that thickness as it moves down the side of the thigh. In drawing figure 5, I have chosen an arbitrary cut at the base of the thigh, at a level where we can find a shape that appears to girdle the top of the thighs, while enveloping the previous shape. The borders of this shape are less clear at the front, but in order to make it easier to draw, I simply follow it and connect it with the almost ever-present layer of fat that

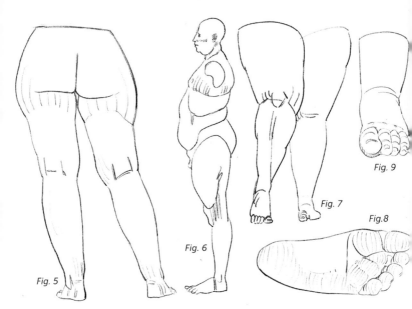

Fig. 5

Fig. 6

Fig. 7

Fig. 8

Fig. 9

covers the top of the adductors on the inside of the thigh.

The shape of the quadriceps can be reinforced in the front by a fatty layer that increases the contrast in the contours in a profile view (Fig. 6).

On the buttocks and the upper thighs around the hips, the fat can take on a considerable thickness; fibrous tracts will then create a multitude of small depressions.

Fat can also cover the inside of the knee. It can augment the shape of the

calf on both sides of the shinbone, thus reinforcing its presence (Fig. 7), as it does with the ulna on the forearm.

On the foot, as on the hand, fat is responsible for the shape of the underside (Fig. 8). Fat plays the important role of a cushion as it absorbs the body's weight and makes the foot stick to the ground better by increasing its contact surface. On a chubby foot, the heads of the metatarsals will be marked by anchoring points (or dimples) (Fig. 9).

drawings

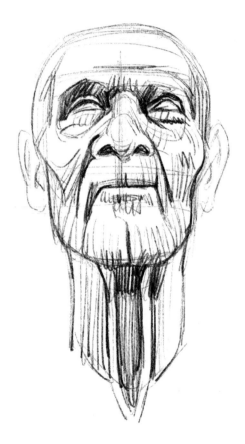

# head and neck

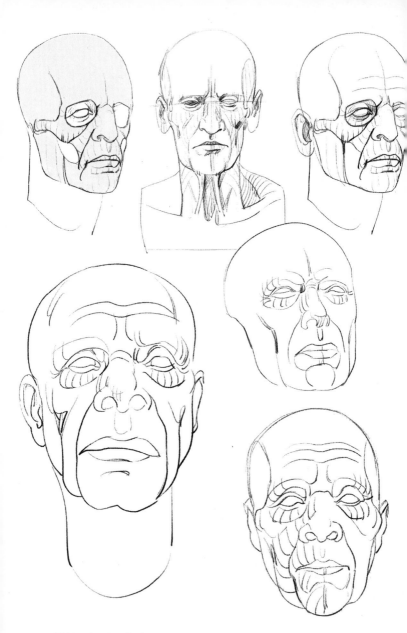

The bony landmarks create outcroppings at the peaks. These consist of the cranial box, orbital frames, cheekbones, and angles of the jaw structure of the face. The skin and fat are suspended from the skeletal frame.

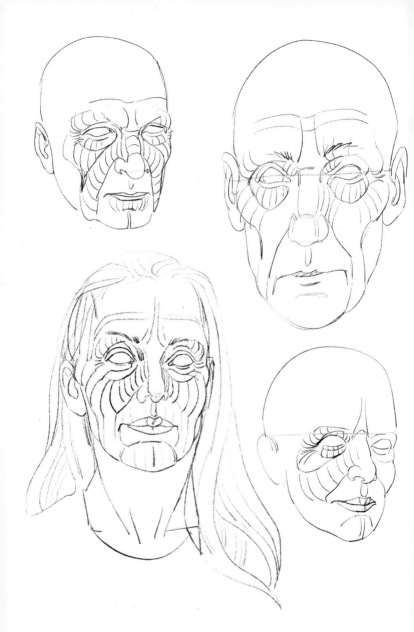

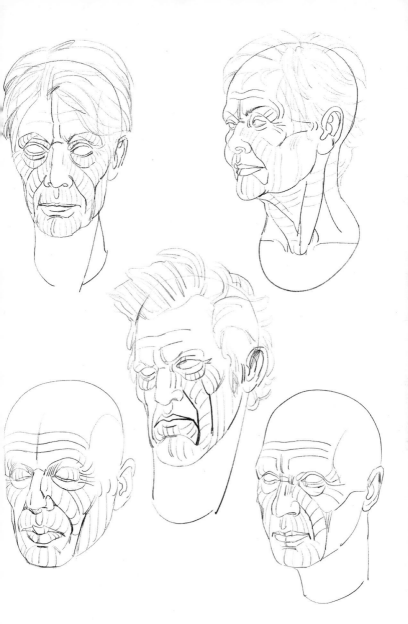

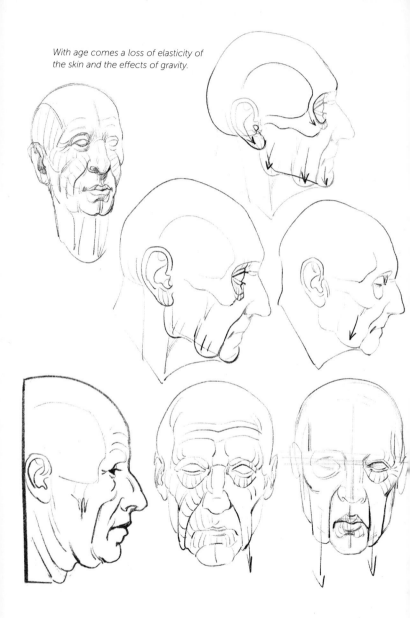

*With age comes a loss of elasticity of the skin and the effects of gravity.*

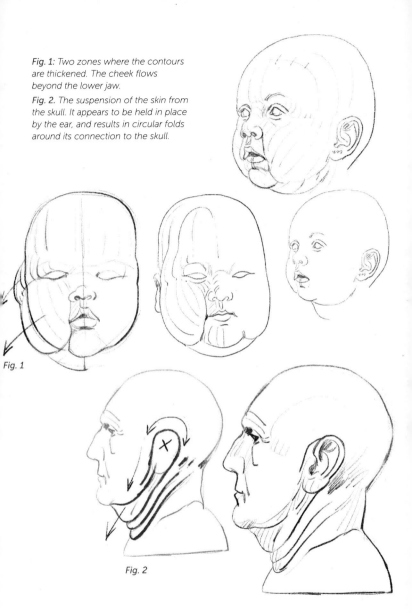

*Fig. 1:* Two zones where the contours are thickened. The cheek flows beyond the lower jaw.

*Fig. 2.* The suspension of the skin from the skull. It appears to be held in place by the ear, and results in circular folds around its connection to the skull.

Fig. 1

Fig. 2

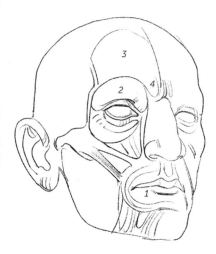

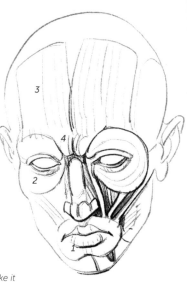

Two circular-shaped muscles (1 and 2) make it possible to close the mouth and eye, while a system of muscles that radiate around the mouth makes it possible to open it.

The frontal bone (3) and the brow bone (4) complete the structure around the eyes.

What we want to draw in these cases is not the muscular fibers but rather their action on the skin. The folds or wrinkles are perpendicular to the direction of the muscle fibers.

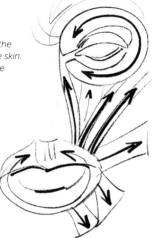

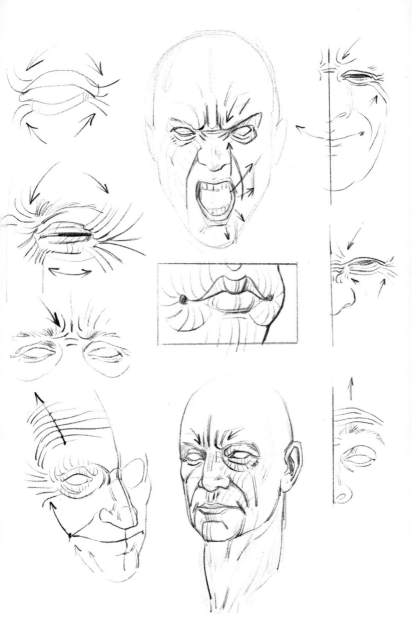

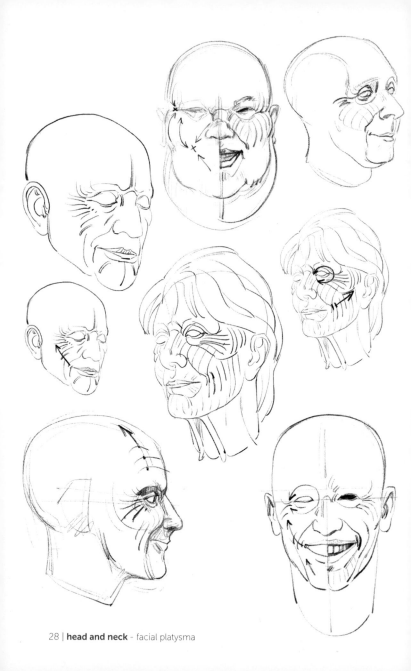

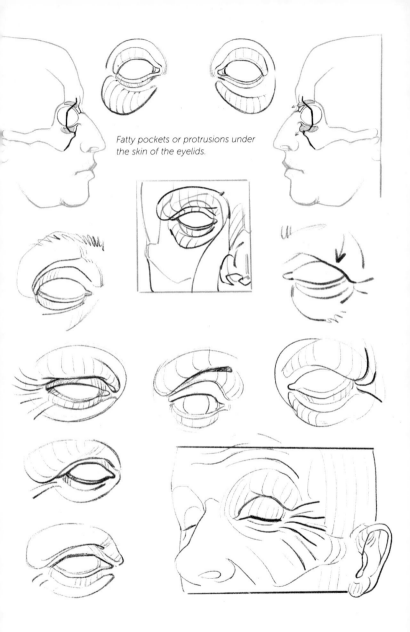

Fatty pockets or protrusions under the skin of the eyelids.

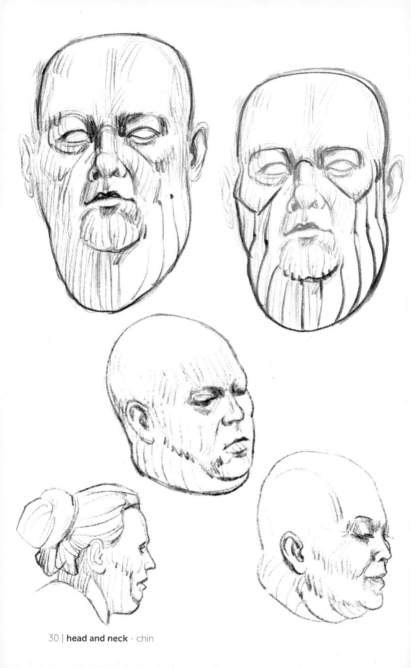

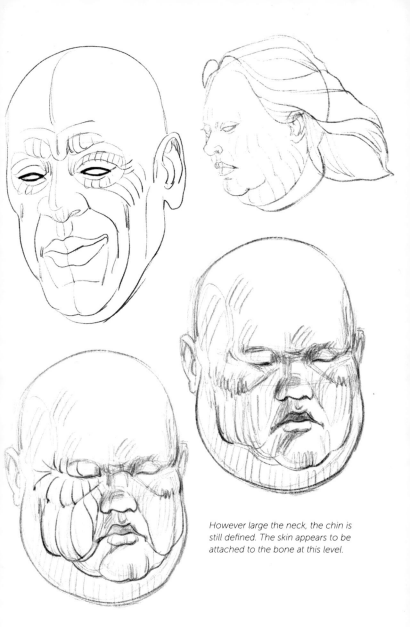

*However large the neck, the chin is still defined. The skin appears to be attached to the bone at this level.*

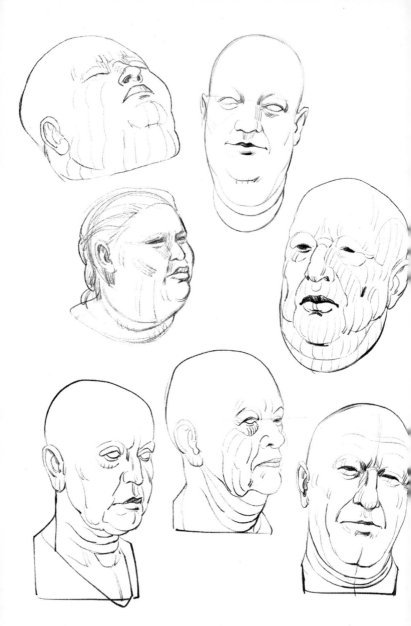

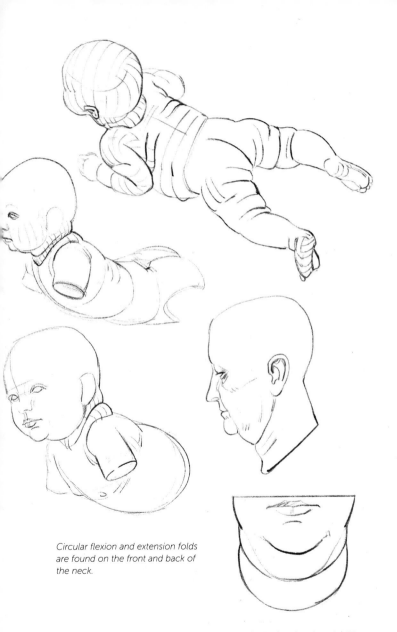

*Circular flexion and extension folds are found on the front and back of the neck.*

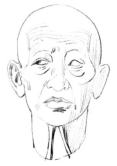

The platysma lines the skin of the neck. From the chin to the corners of the lips, it descends beyond the collarbone.

With age, it is visible in the shape of two vertical cords at the front of the throat. These cords are suspended from the chin and move apart from each other as they descend.

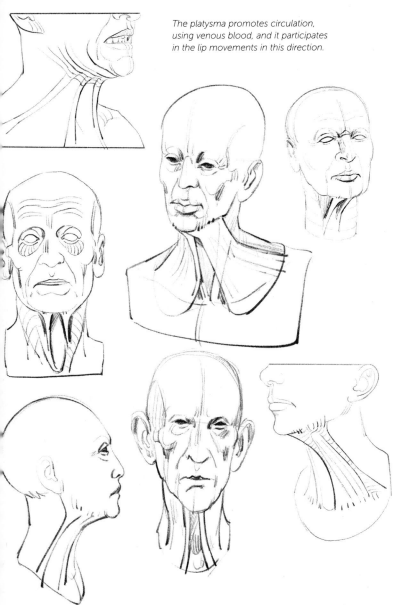

*The platysma promotes circulation, using venous blood, and it participates in the lip movements in this direction.*

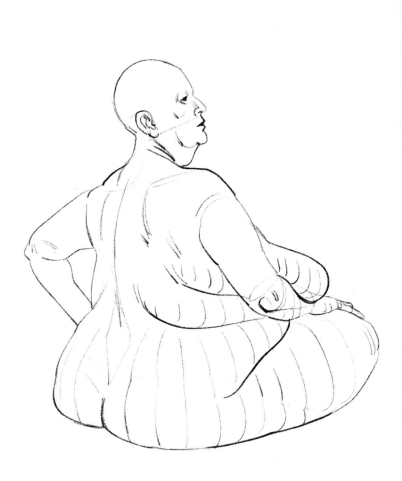

torso

This two-page spread presents variations on exhibit 1, shown on page 12 of the introduction.

The flank does not merge with the shape of the hip (1 and 2).

*Fig. 1:* The upper edge of the pelvis marks the border between these two regions.

*Fig. 1*

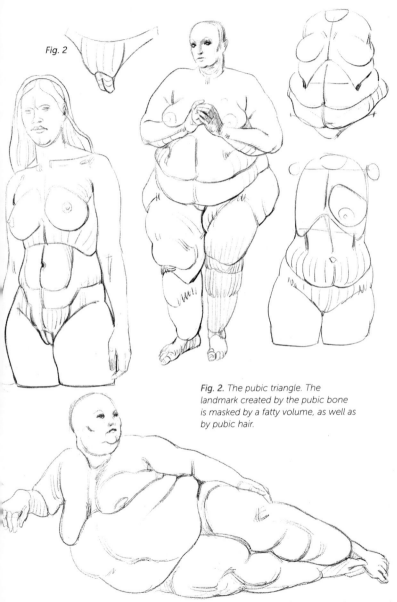

Fig. 2

*Fig. 2.* The pubic triangle. The
landmark created by the pubic bone
is masked by a fatty volume, as well as
by pubic hair.

exhibit 1 - **torso** | 39

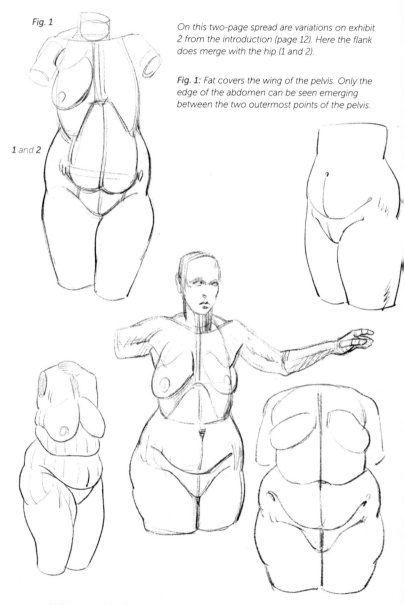

**Fig. 1**

*On this two-page spread are variations on exhibit 2 from the introduction (page 12). Here the flank does merge with the hip (1 and 2).*

*Fig. 1: Fat covers the wing of the pelvis. Only the edge of the abdomen can be seen emerging between the two outermost points of the pelvis.*

1 and 2

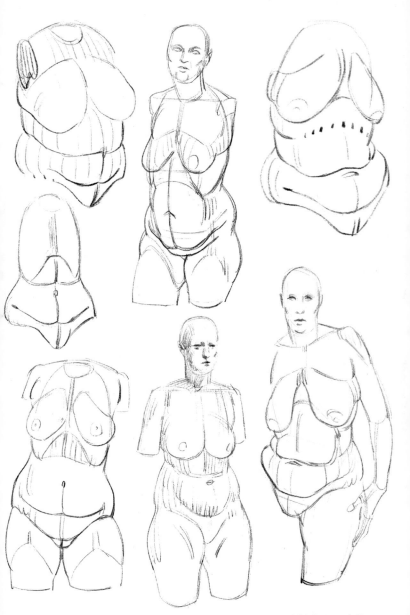

exhibit 2 - **torso** | 41

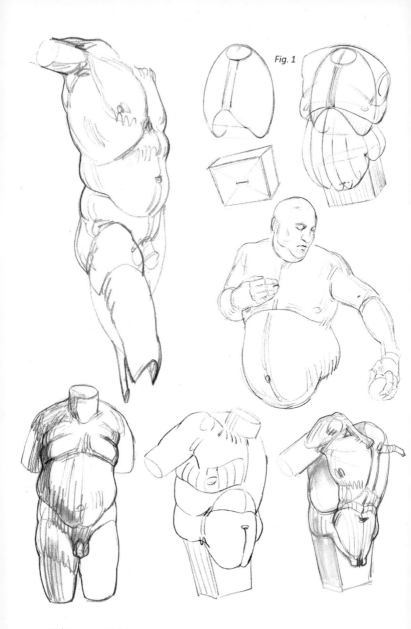

Fig. 1

*Fig. 1:* We can see the first exhibit here on a series of masculine models. The demarcation of the flank above the hips is more visible in males.

*Figs. 2, 3, and 4:* Distinctive shapes on the lower part of the abdomen. The fat creates a doubling effect when it splits in two.

Fig. 2

Fig. 3

Fig. 4

*Fig. 5:* The fat volume on the pubis, hidden by the pubic hair. As the fat increases, this shape encroaches on the base of the penis and makes it appear shorter.

Fig. 5

exhibit 1 - **torso** | 43

**Fig. 1:** Distribution of the main volumes of fat.

**Fig. 2:** With extra weight, a fold is created that joins the nipple and breast to the tip of the scapula (I). A second fold emphasizes the volume of the rib cage (II). The third fold, if the fat remains localized in the area above the pelvis (exhibit 1), demarcates the boundary of the flank (III).

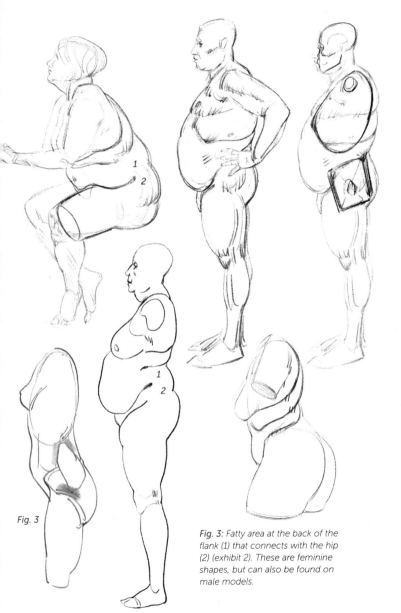

*Fig. 3:* Fatty area at the back of the flank (1) that connects with the hip (2) (exhibit 2). These are feminine shapes, but can also be found on male models.

*Fig. 3*

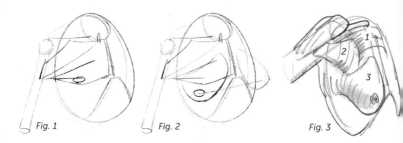

**From left to right:** *The pectoral (Fig. 1) and the breast (Fig. 2). Fig. 3 is the morphological version, showing the three layers superimposed on each other: The skeleton (1), the muscles (2), and the fat of the breast (3), which connects in the back with the scapular area.*

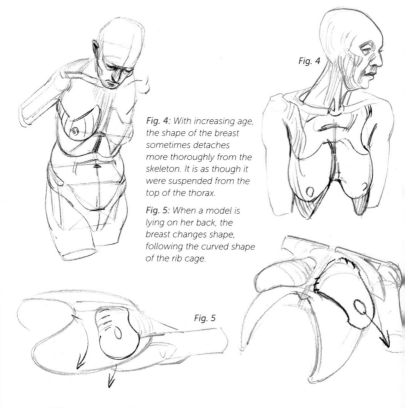

**Fig. 4:** *With increasing age, the shape of the breast sometimes detaches more thoroughly from the skeleton. It is as though it were suspended from the top of the thorax.*

**Fig. 5:** *When a model is lying on her back, the breast changes shape, following the curved shape of the rib cage.*

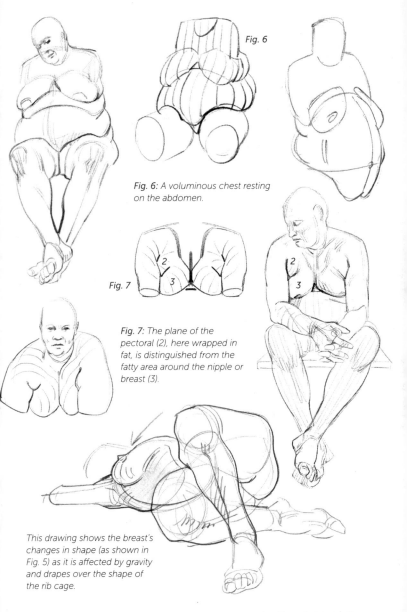

*Fig. 6:* A voluminous chest resting on the abdomen.

*Fig. 6*

*Fig. 7*

*Fig. 7:* The plane of the pectoral (2), here wrapped in fat, is distinguished from the fatty area around the nipple or breast (3).

This drawing shows the breast's changes in shape (as shown in Fig. 5) as it is affected by gravity and drapes over the shape of the rib cage.

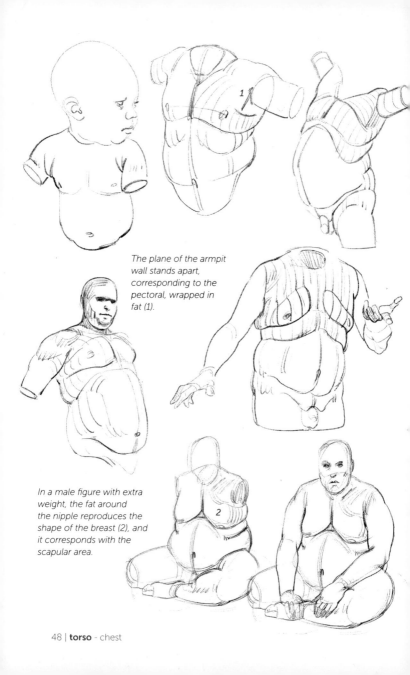

The plane of the armpit wall stands apart, corresponding to the pectoral, wrapped in fat (1).

In a male figure with extra weight, the fat around the nipple reproduces the shape of the breast (2), and it corresponds with the scapular area.

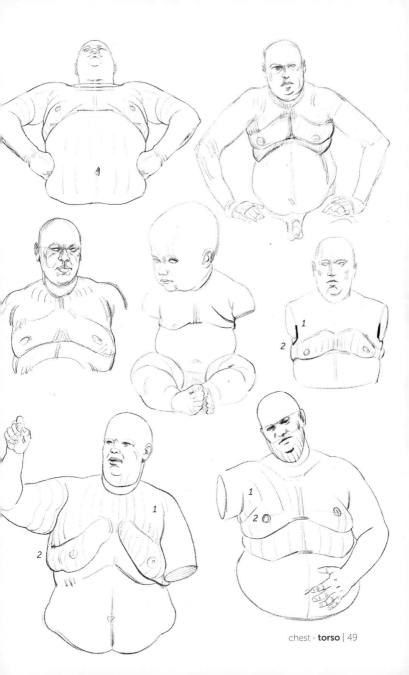

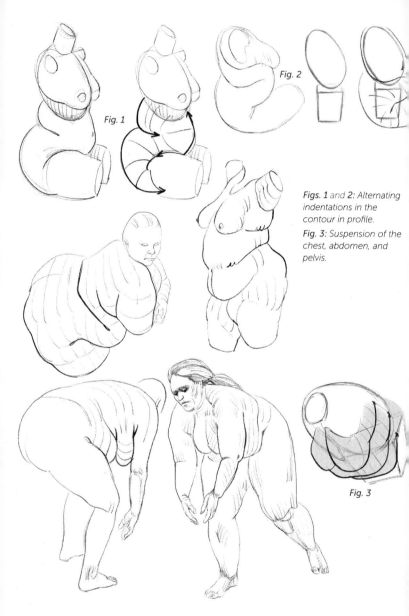

*Figs. 1* and *2*: Alternating indentations in the contour in profile.

*Fig. 3*: Suspension of the chest, abdomen, and pelvis.

Fig. 1

Fig. 2

Fig. 3

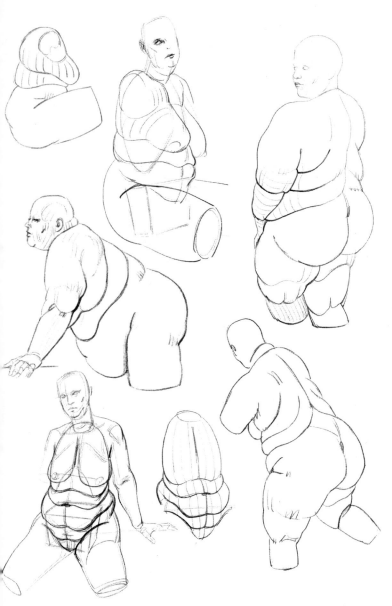

Prominence of the bony reference points of the two posterior iliac tips and the tip of the sacrum (2).

The skin is attached to these three points. The accumulation of fat underneath the skin causes these points to show up as the low point of a dimple. The tip of the sacrum coincides with the beginning line of the buttocks.

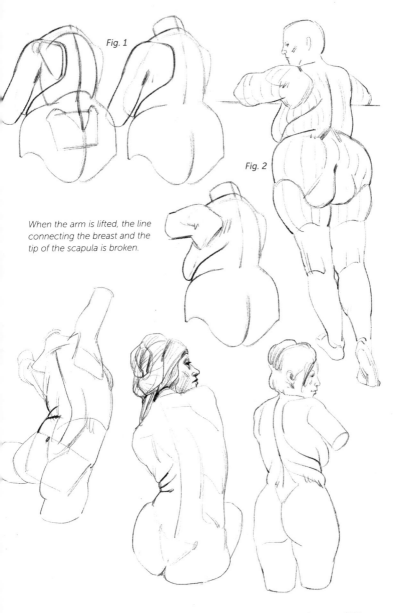

Fig. 1

Fig. 2

*When the arm is lifted, the line connecting the breast and the tip of the scapula is broken.*

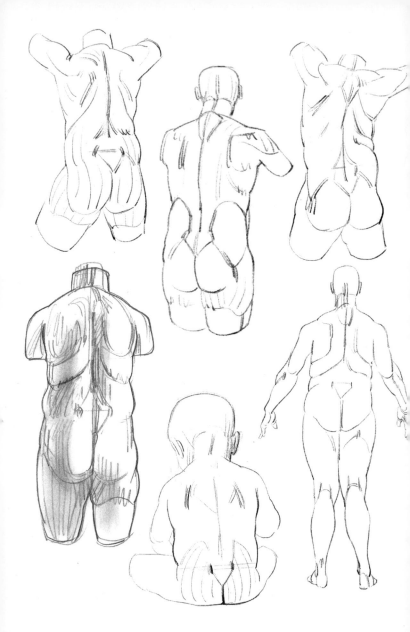

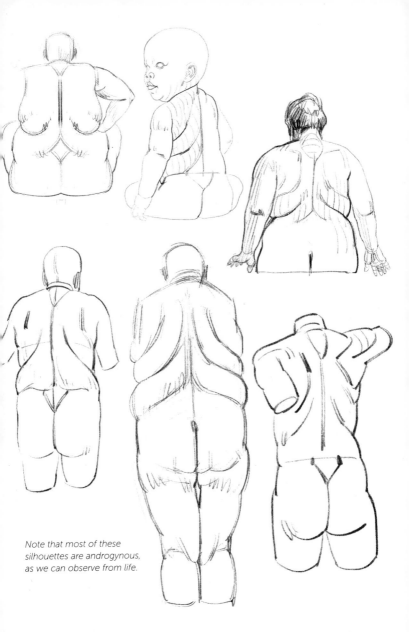

*Note that most of these silhouettes are androgynous, as we can observe from life.*

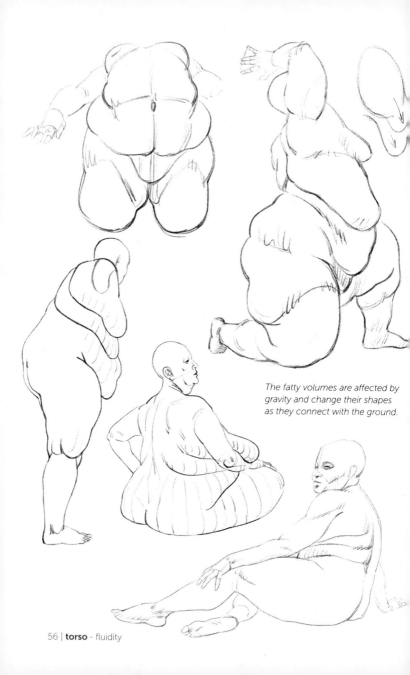

*The fatty volumes are affected by gravity and change their shapes as they connect with the ground.*

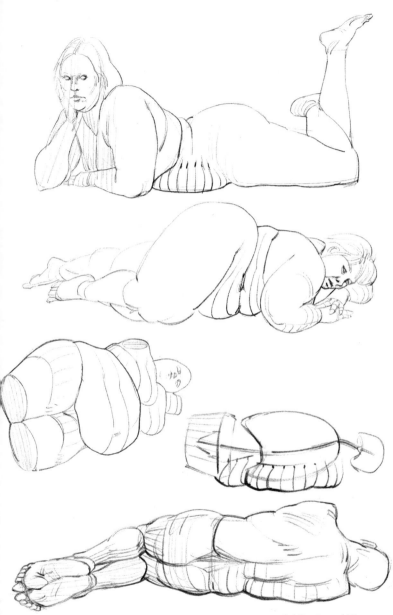

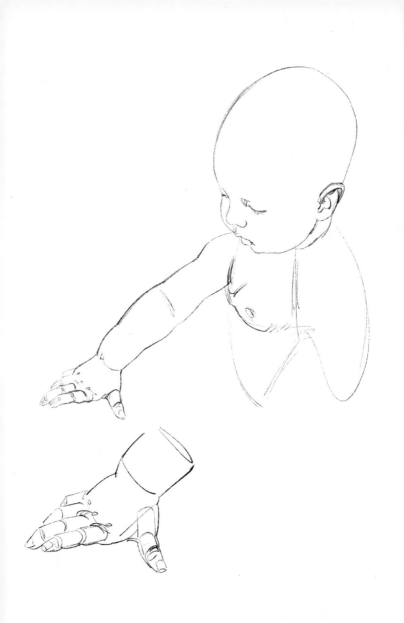

upper limb

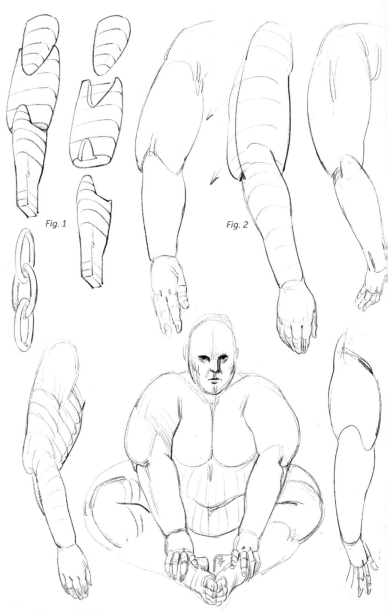

Fig. 1

Fig. 2

*Fig. 1:* Sequence of shoulder, arm, and forearm segments.

*Fig. 2:* The contours between segments diminishes with increased weight.

*Fig. 3:* The fat layer is often thinner on the forearm, allowing the musculature to be visible.

*Fig. 4:* The ulna remains visible from the elbow to the wrist as a groove, the depth of which depends on the thickness of the fat layer.

*Fig. 3*

*Fig. 4*

When the arm is against the torso, the armpit area becomes more complex. As the various fleshy masses meet, secondary shapes are created, like folds in an article of clothing.

*When the arm is lifted, the suspension of the breast from the clavicle is more obvious.*

Fig. 1

*Figs. 1 and 2: The shape of the fat can be seen underneath the shape of the triceps.*

Fig. 2

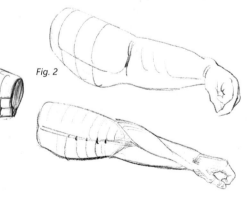

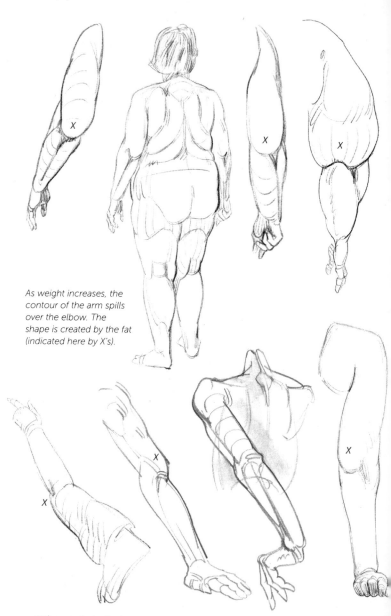

*As weight increases, the contour of the arm spills over the elbow. The shape is created by the fat (indicated here by X's).*

*The nesting of the forearm and underarm. On the outer side of the elbow, the contour continues higher up.*

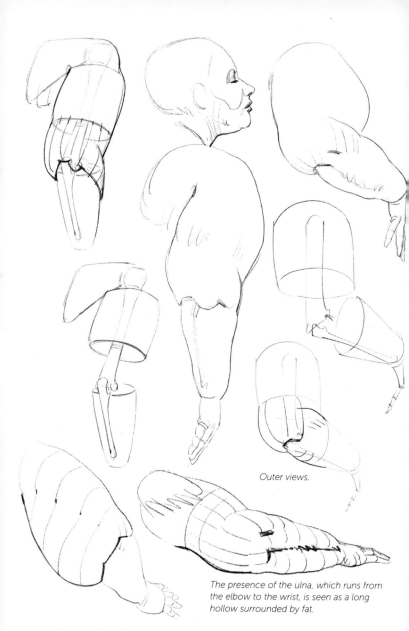

*Outer views.*

*The presence of the ulna, which runs from the elbow to the wrist, is seen as a long hollow surrounded by fat.*

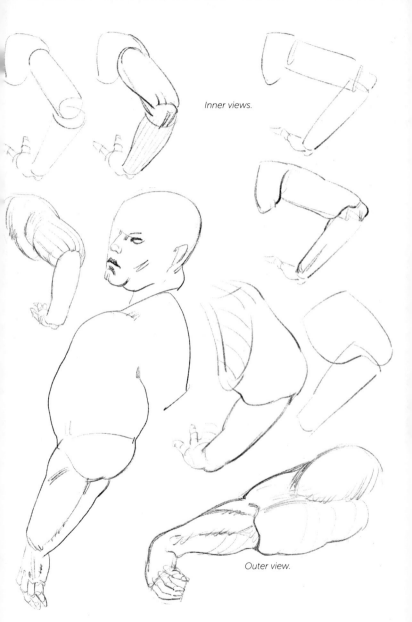

*Inner views.*

*Outer view.*

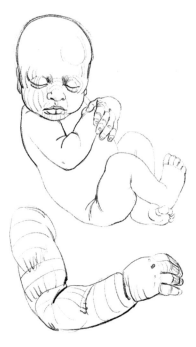

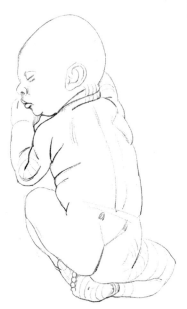

*Flexion fold (1) and additional folds (2) on the arms of babies.*

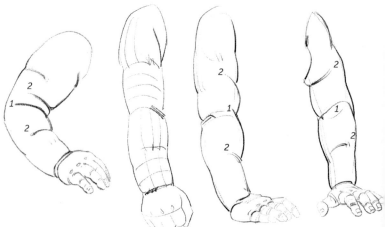

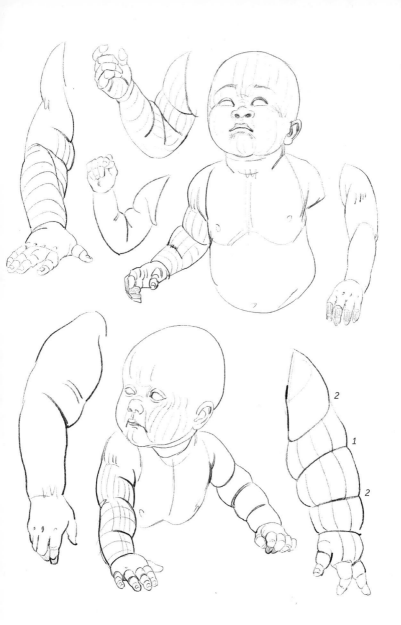

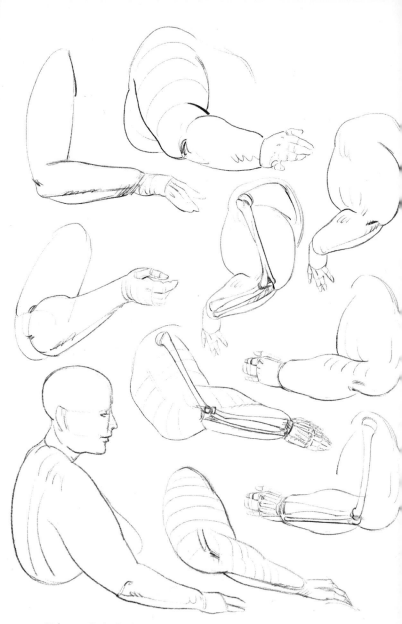

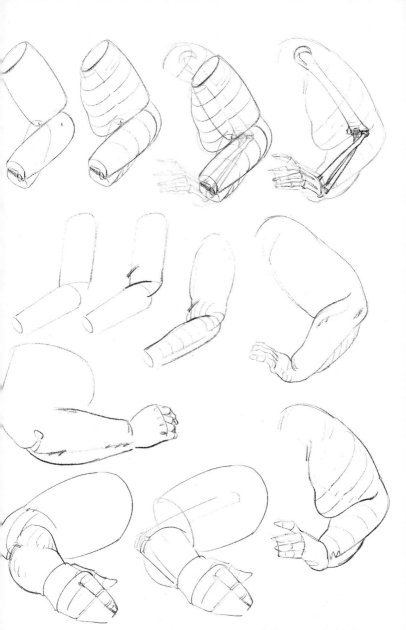

Here, as on a baby's arm, we find the flexion fold (1) framed by secondary folds (2).

We also find the curved folds that, like a fold in fabric, can be found every time multiple fleshy masses come into contact with each other during bending motions.

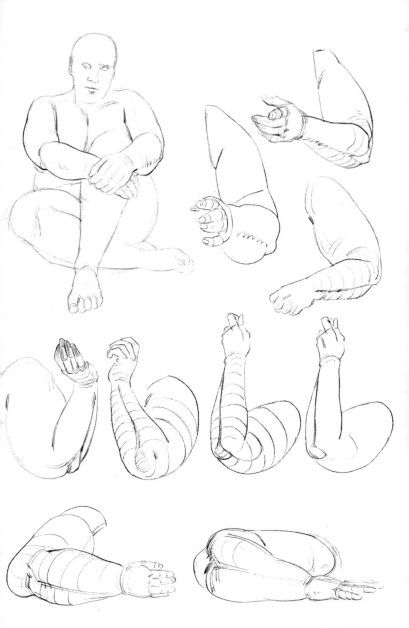

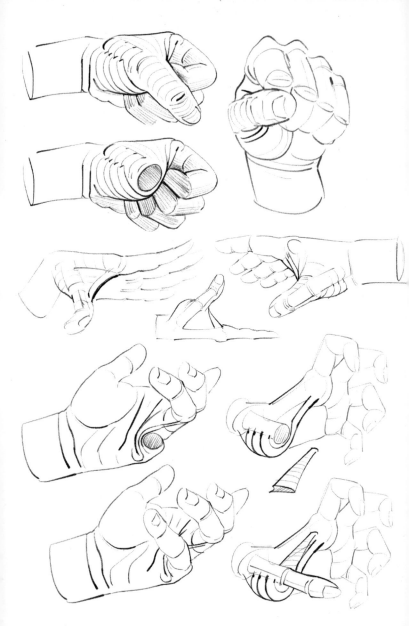

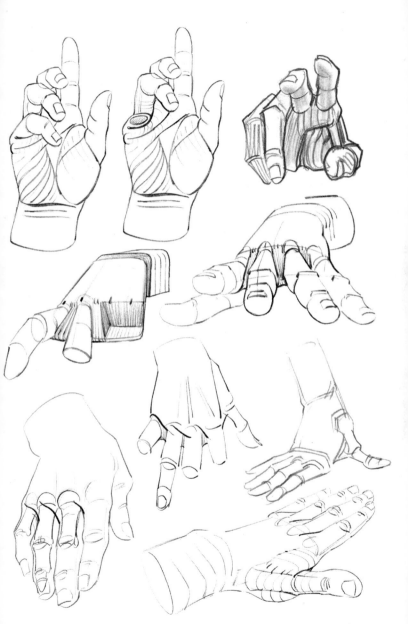

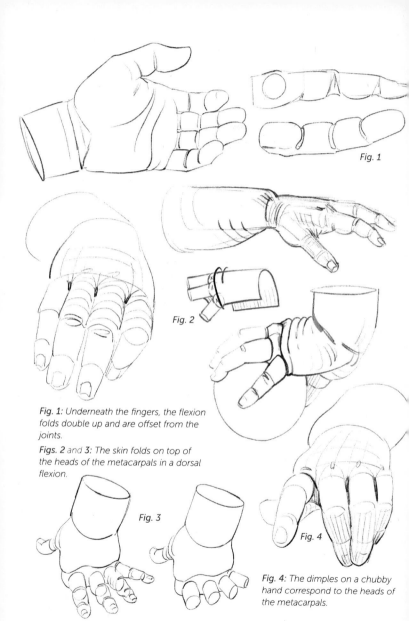

**Fig. 1:** Underneath the fingers, the flexion folds double up and are offset from the joints.

**Figs. 2** and **3:** The skin folds on top of the heads of the metacarpals in a dorsal flexion.

*Fig. 1*

*Fig. 2*

*Fig. 3*

*Fig. 4*

**Fig. 4:** The dimples on a chubby hand correspond to the heads of the metacarpals.

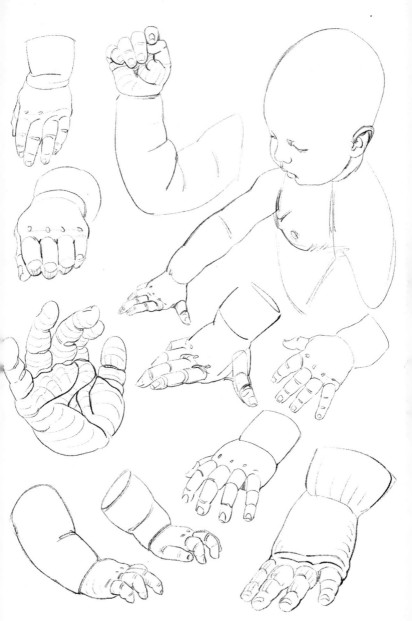

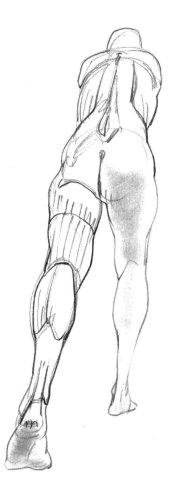

lower limb

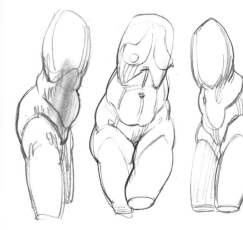

With more fat, the fatty region below the hip joint can connect with the area around the adductors. I have chosen to girdle the top of the thighs here to simplify the drawing.

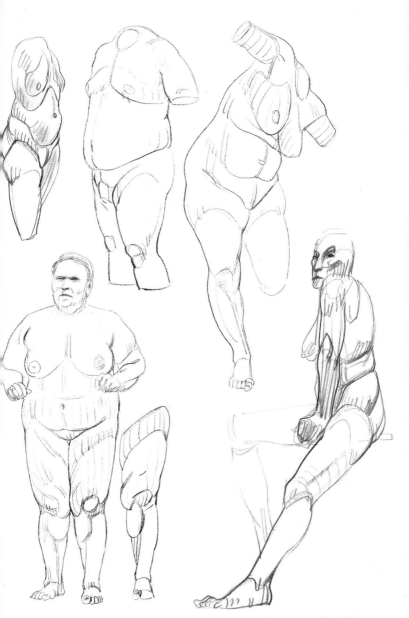

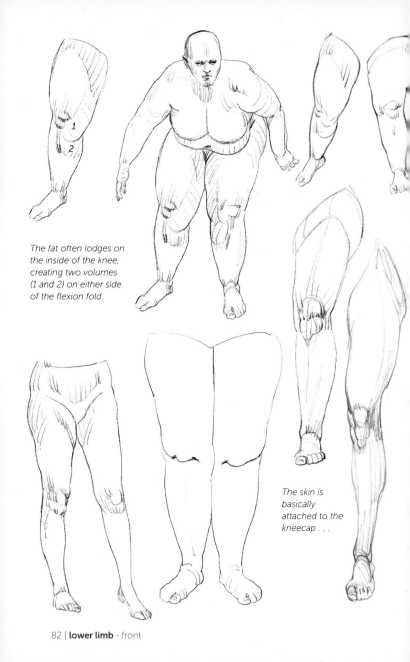

The fat often lodges on the inside of the knee, creating two volumes (1 and 2) on either side of the flexion fold.

The skin is basically attached to the kneecap . . .

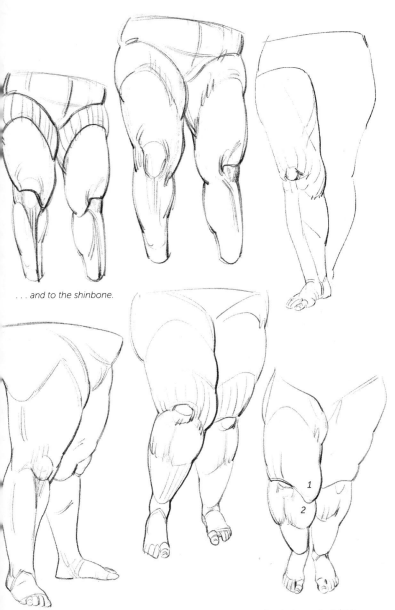

*. . . and to the shinbone.*

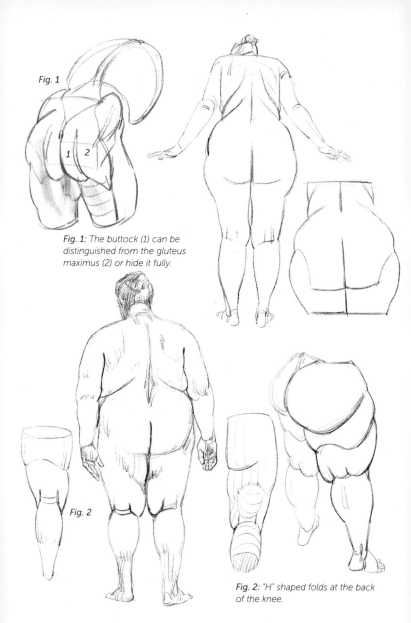

*Fig. 1*

**Fig. 1:** *The buttock (1) can be distinguished from the gluteus maximus (2) or hide it fully.*

*Fig. 2*

**Fig. 2:** *"H" shaped folds at the back of the knee.*

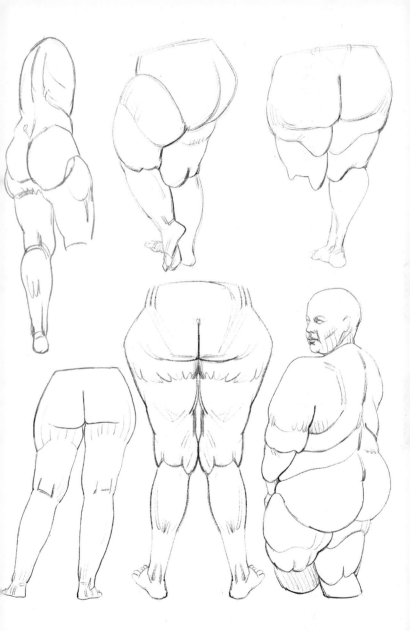

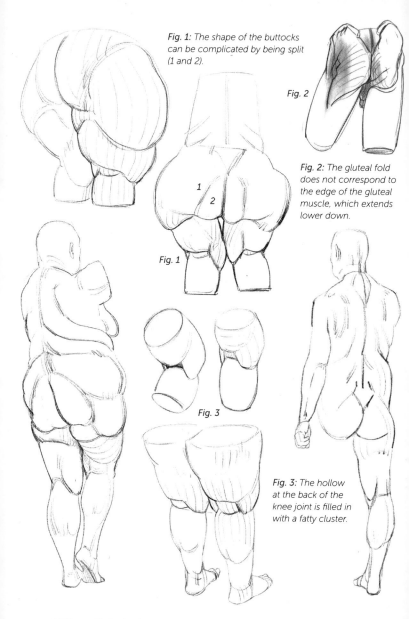

**Fig. 1:** The shape of the buttocks can be complicated by being split (1 and 2).

Fig. 2

**Fig. 2:** The gluteal fold does not correspond to the edge of the gluteal muscle, which extends lower down.

1

2

Fig. 1

Fig. 3

**Fig. 3:** The hollow at the back of the knee joint is filled in with a fatty cluster.

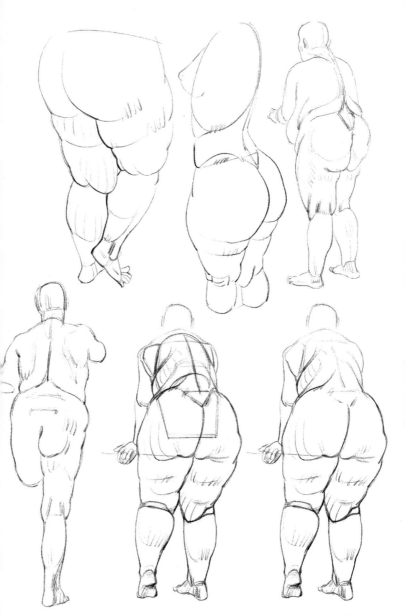

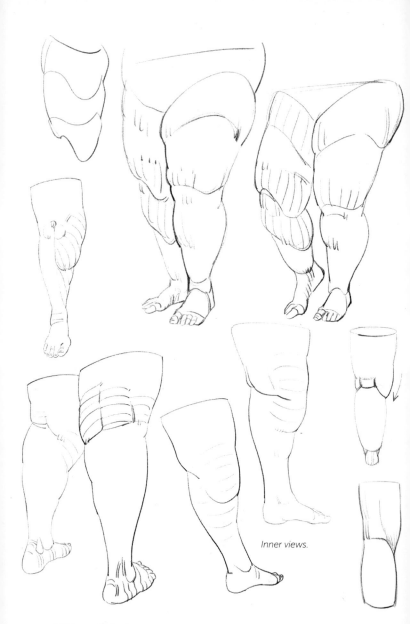

*Inner views.*

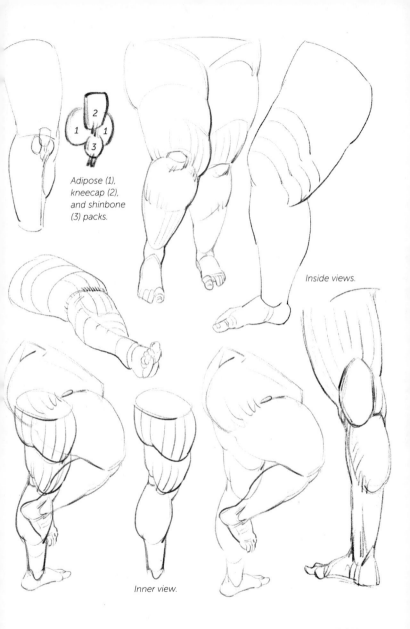

Adipose (1), kneecap (2), and shinbone (3) packs.

Inside views.

Inner view.

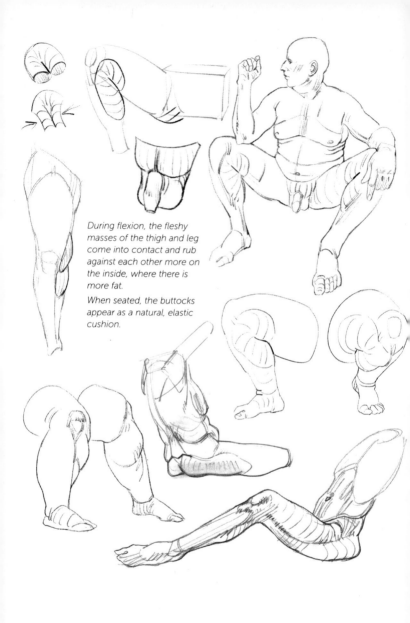

During flexion, the fleshy masses of the thigh and leg come into contact and rub against each other more on the inside, where there is more fat.

When seated, the buttocks appear as a natural, elastic cushion.

Fig. 1

Fig. 3

Fig. 2

Figs. 1, 2, and 3: The
bony reference point
created by the kneecap
is transformed into a
recessed anchoring
point by the increase
in the surrounding fatty
layer.

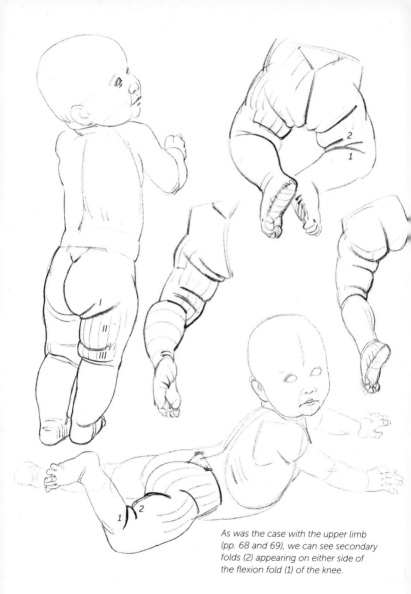

*As was the case with the upper limb (pp. 68 and 69), we can see secondary folds (2) appearing on either side of the flexion fold (1) of the knee.*

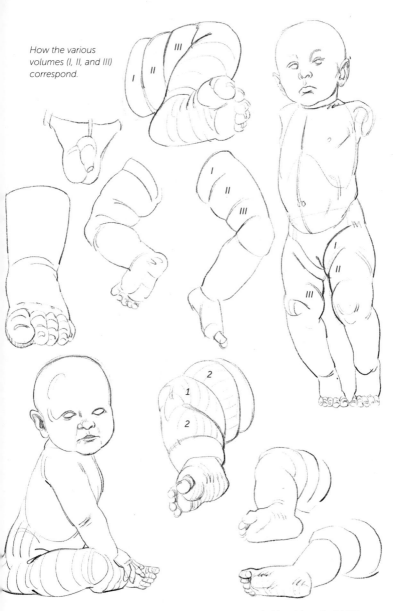

*How the various volumes (I, II, and III) correspond.*

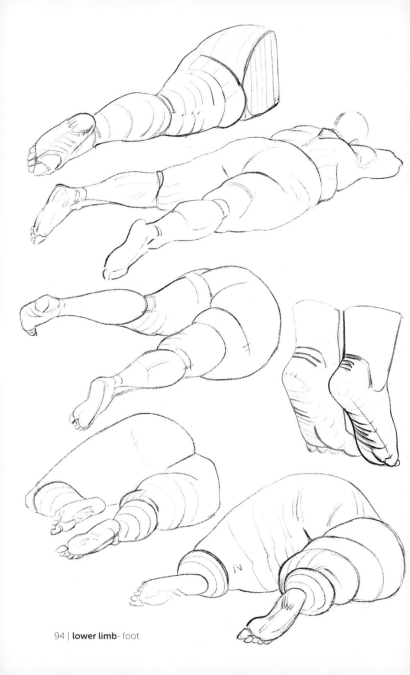

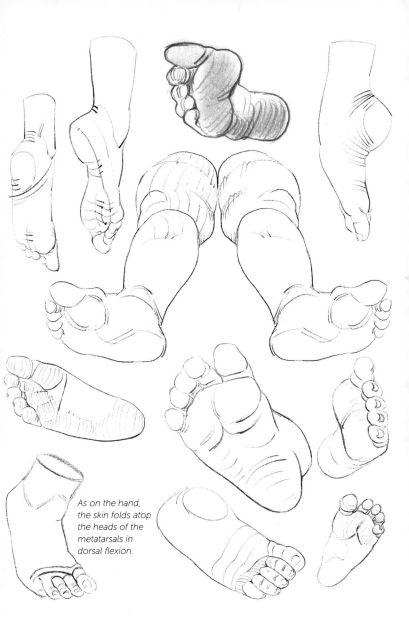

*As on the hand, the skin folds atop the heads of the metatarsals in dorsal flexion.*

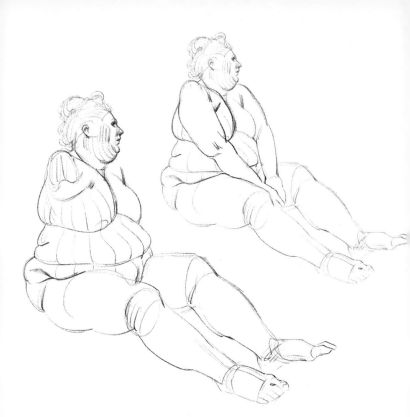

# resources

(Note: These are resources listed in the original French edition.)

Gottfried Bammes, *Der nackte Mensch*, Dresden, Veb Verlag der Kunst, 1982.

Alain Bouchet and Jacques Cuilleret, *Anatomie topographique et fonctionnelle*, Paris, Simep, 1983.

Paul Richer, *Nouvelle anatomie artistique*, Paris, Librairie Plon, 1906-1920, 2 volumes.

# Don't Close
# The Book
# On Us!

Sign up today to receive a copy
of *An Introduction to Morpho
Anatomy Drawing Basics* ebook

Plus access to:
- Discounts
- Free Online Events
- Exclusive Content
- And More!

www.rockynook.com/drawing-newsletter